Rescue Me Horses

Cate Edwards

Travel Edition

Copywrite Cate Edwards/Little Thorns Books ©

All rights reserved. This book or any portion thereof may not be reproduced or used in any manner whatsoever without the express written permission of the publisher except for the use of brief notations in a book review. If you received this book as an ARC please note that digital copies are strictly for reviewers and may not be sold or redistributed. Littlethornsbooks@gmail.com

ISBN-13: 978-1542361033
ISBN-10: 1542361036

A special thanks to my husband Shawn....
for all the laughs and being my best friend.

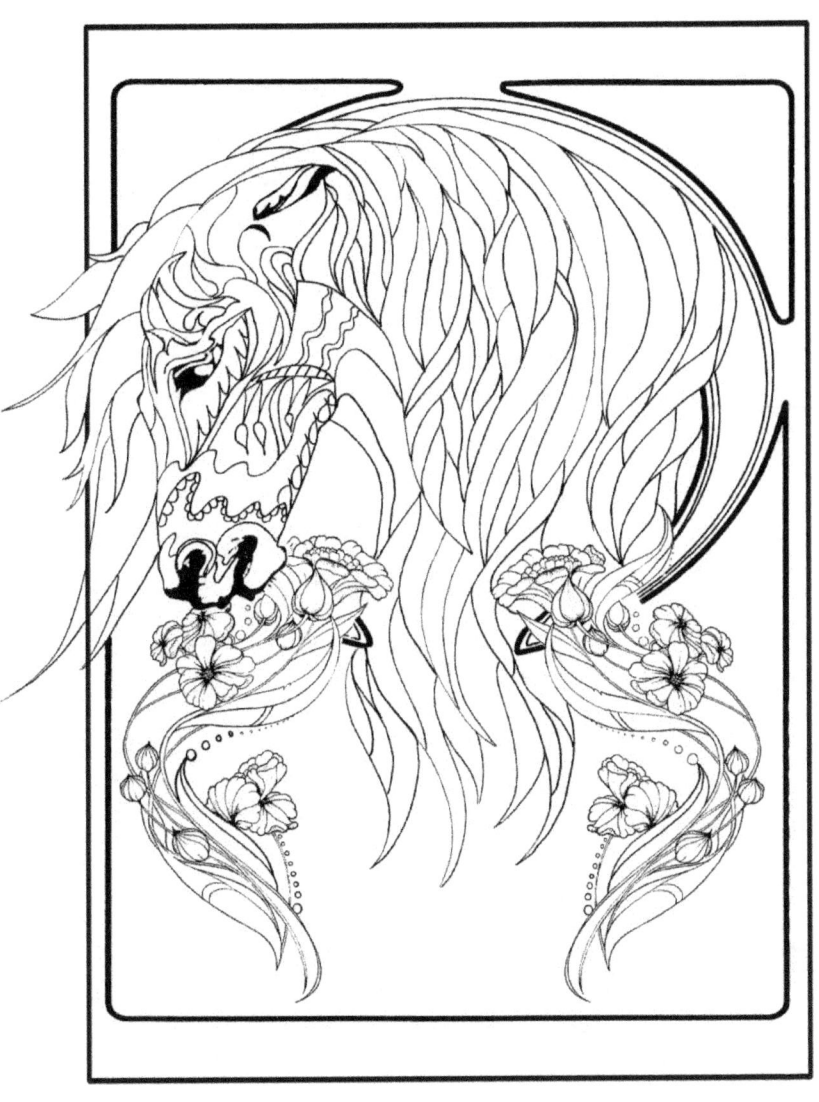

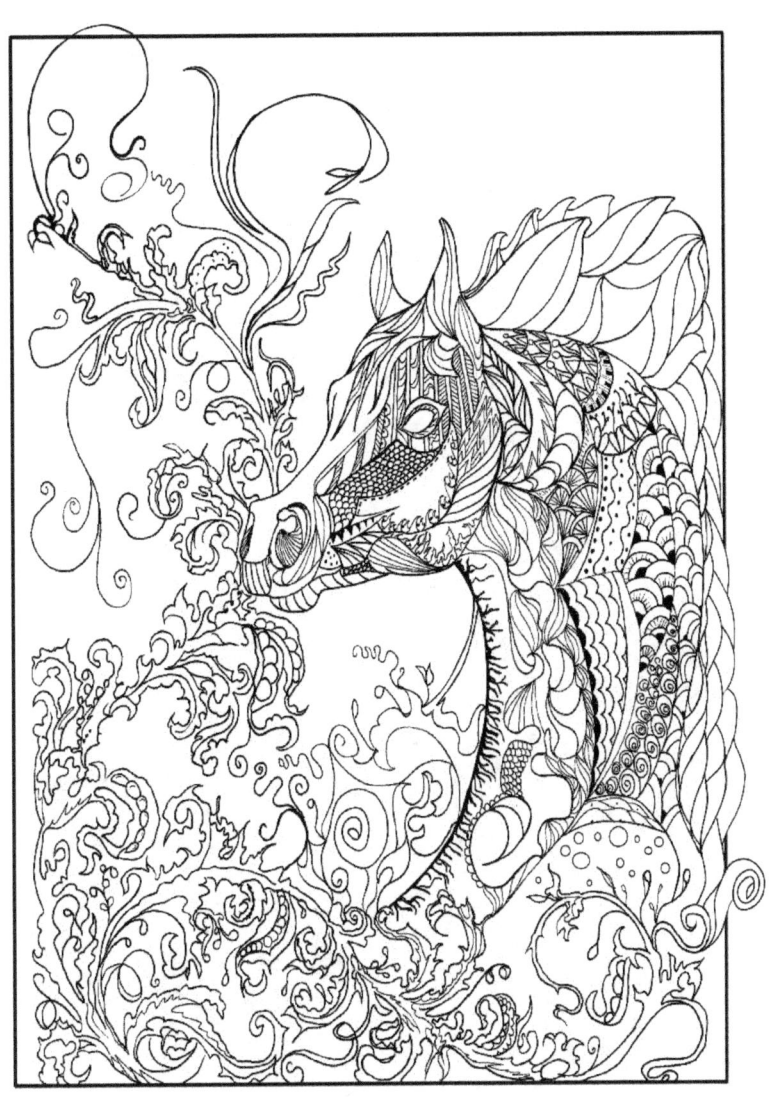

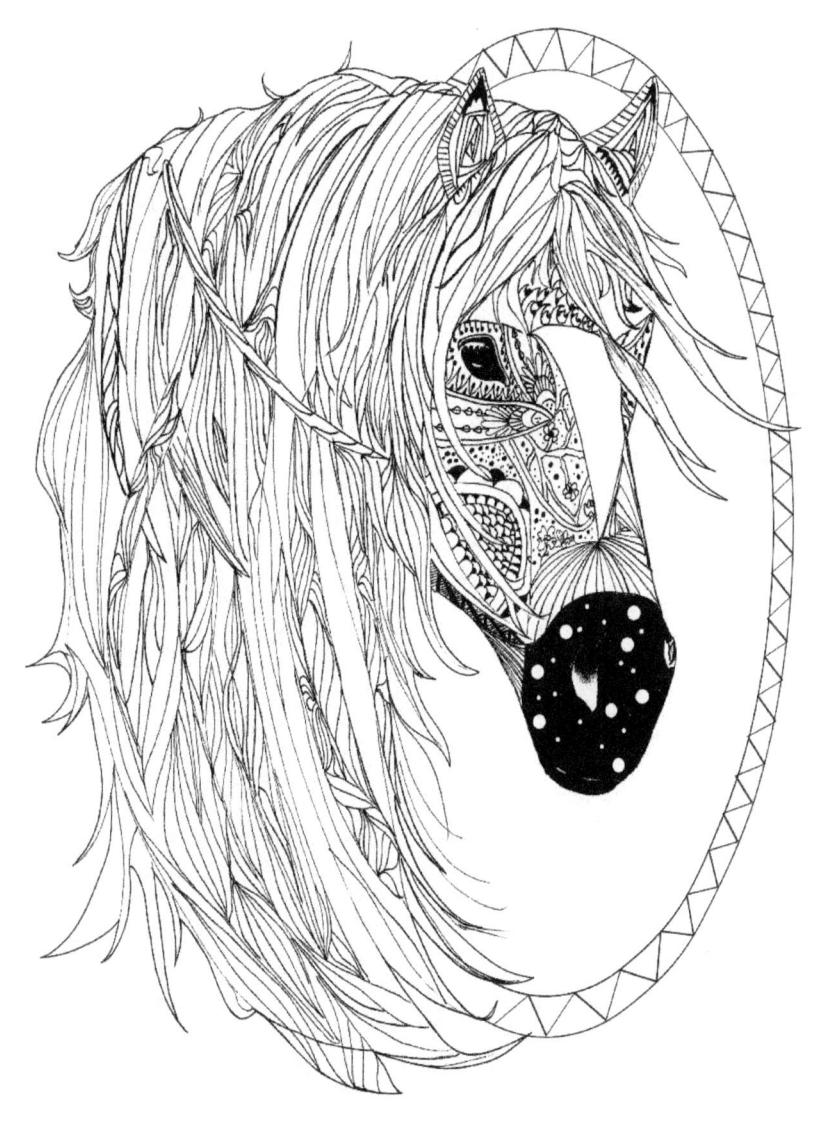

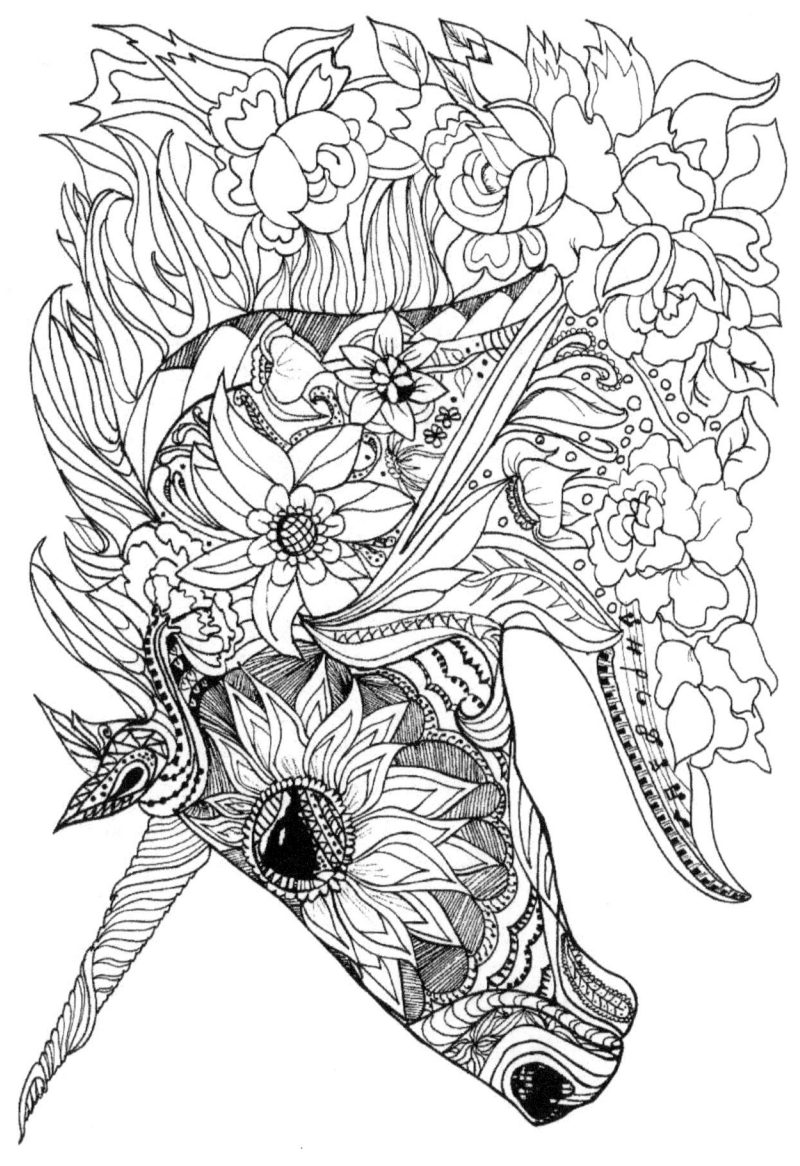

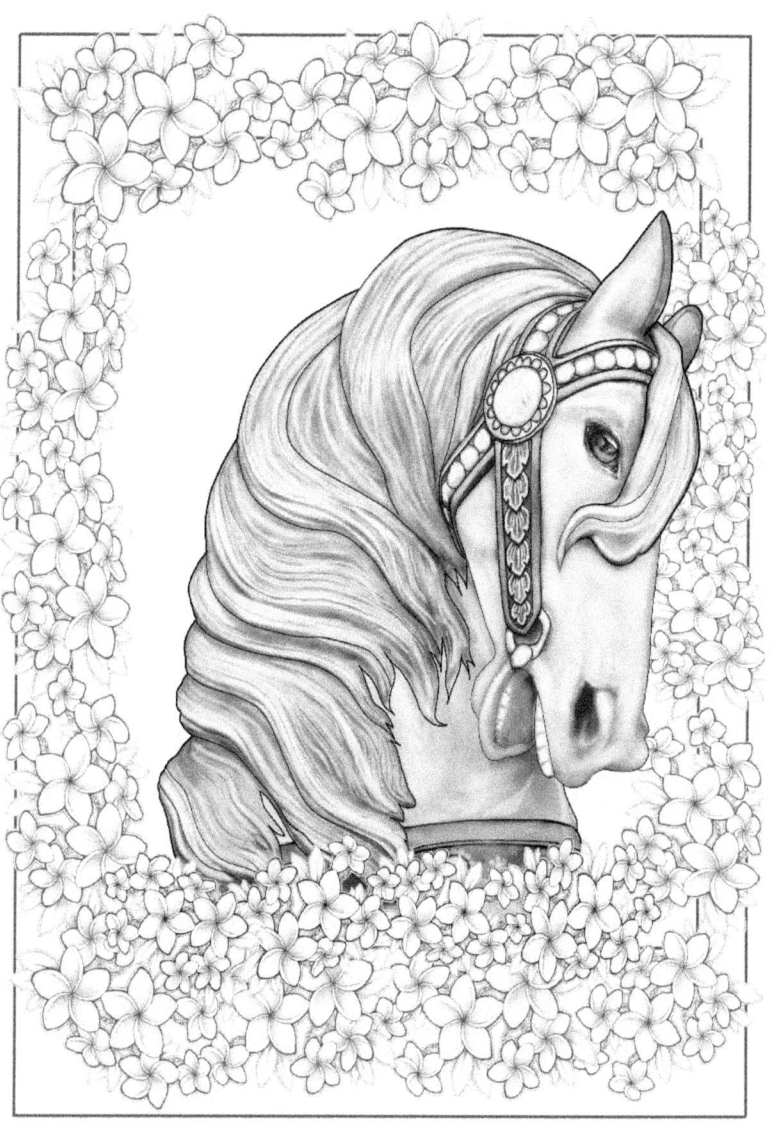

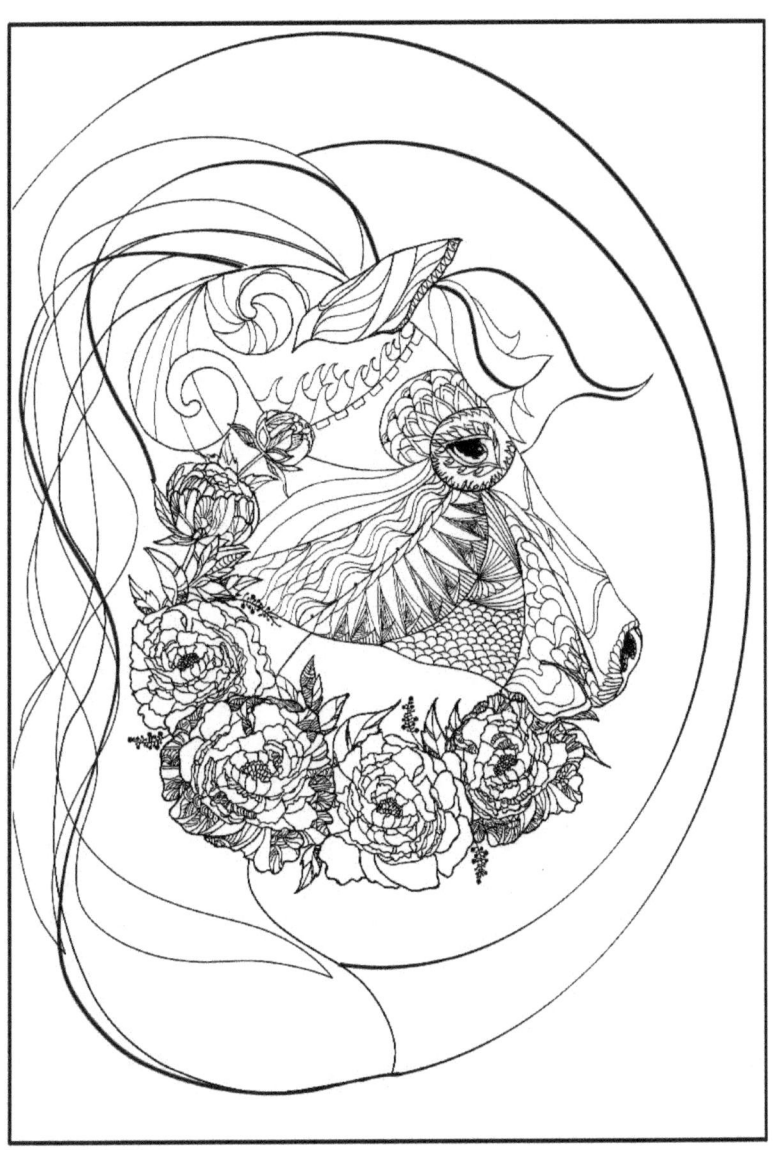

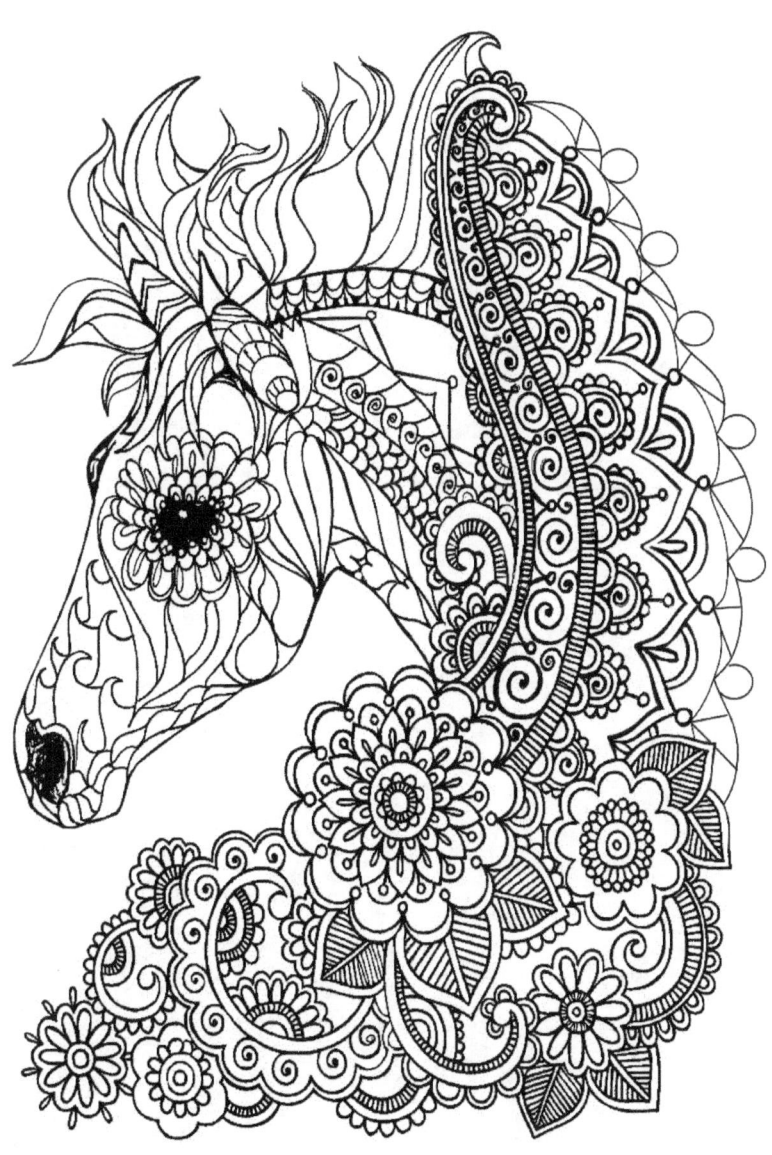

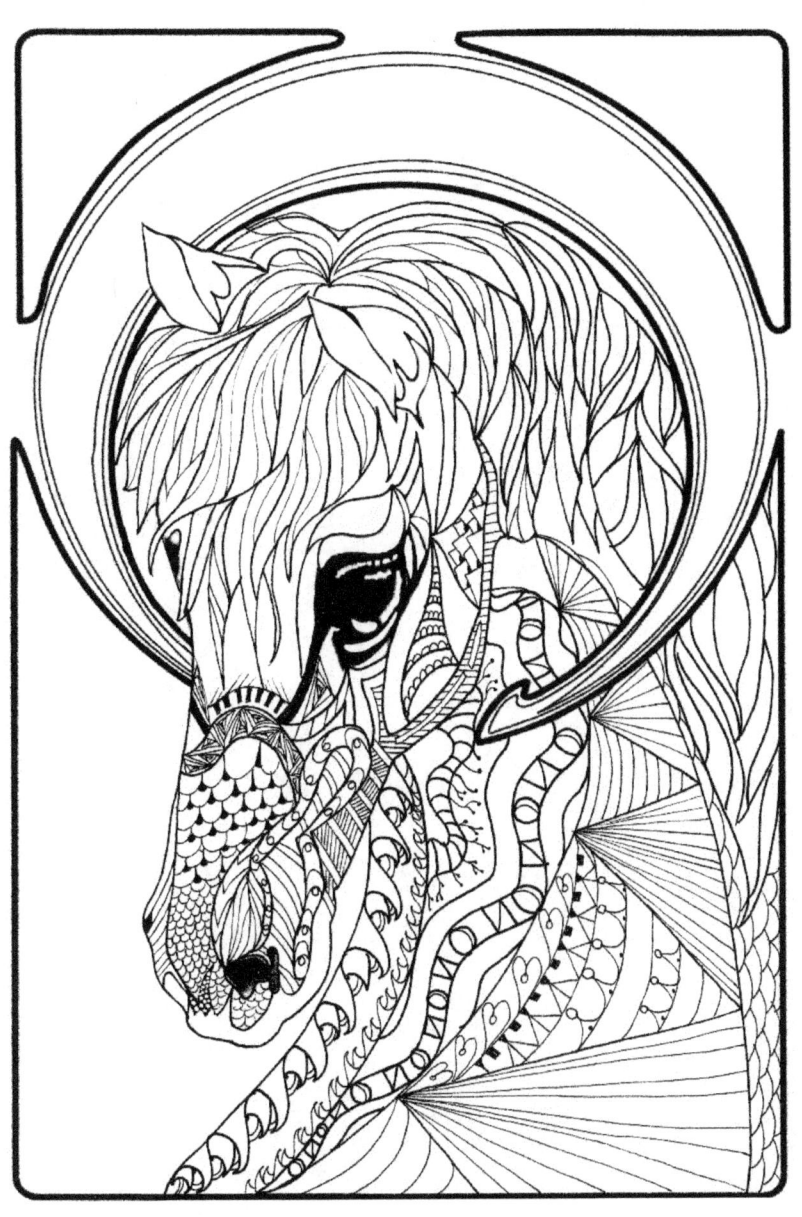

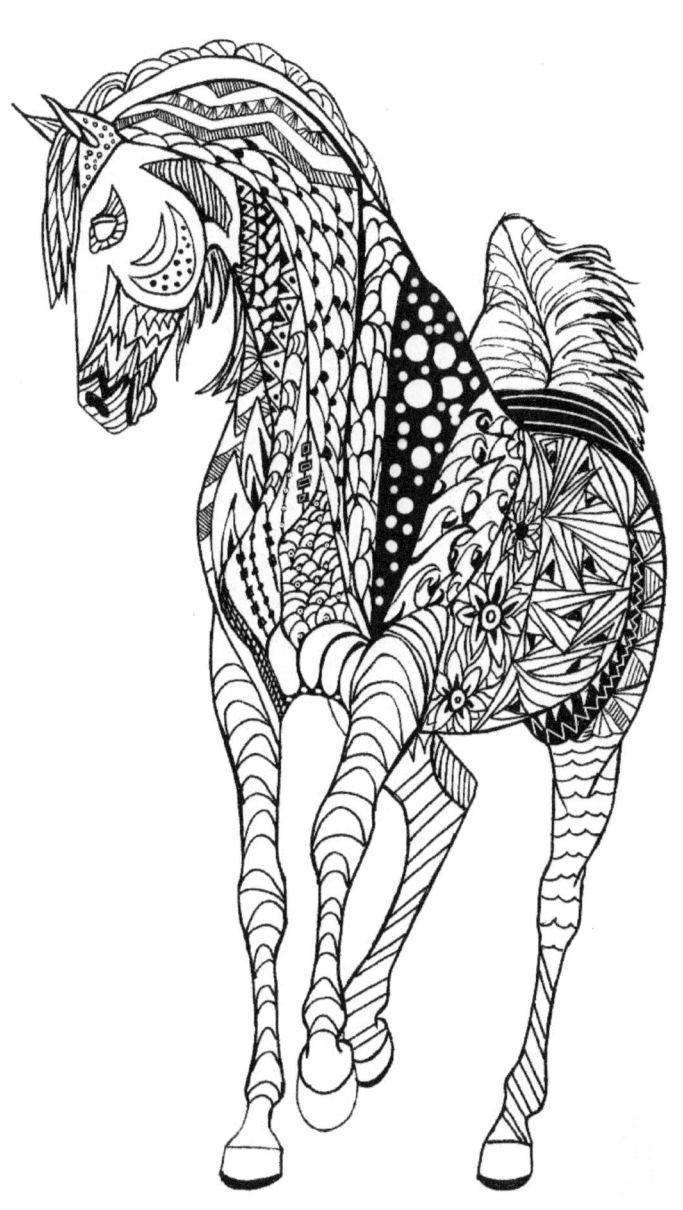

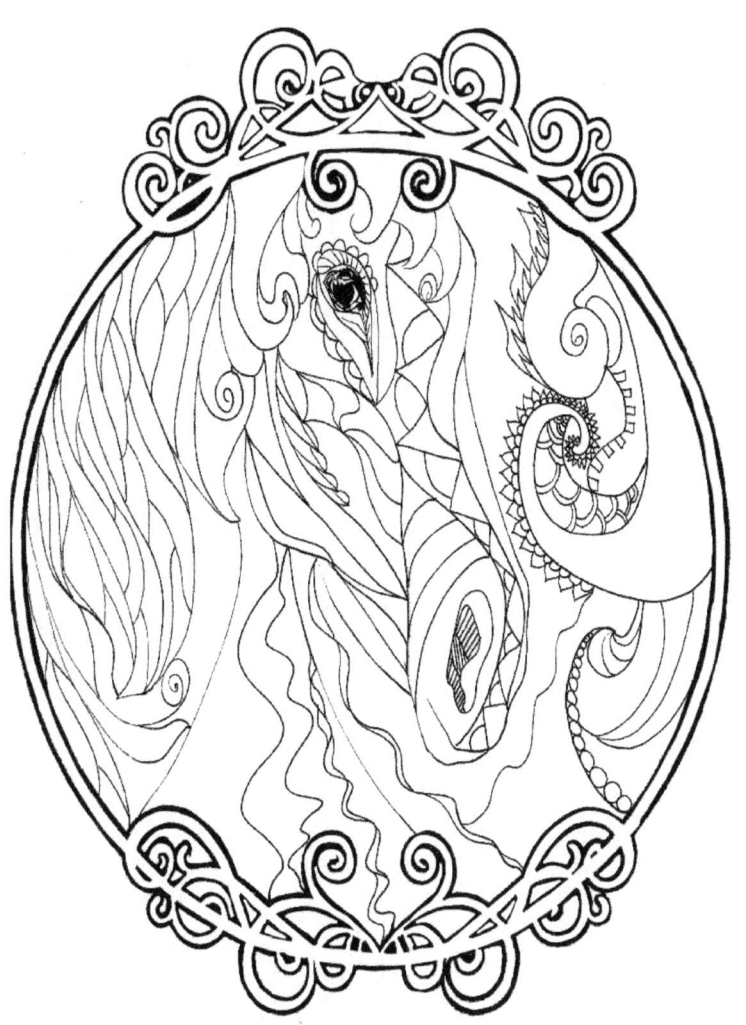

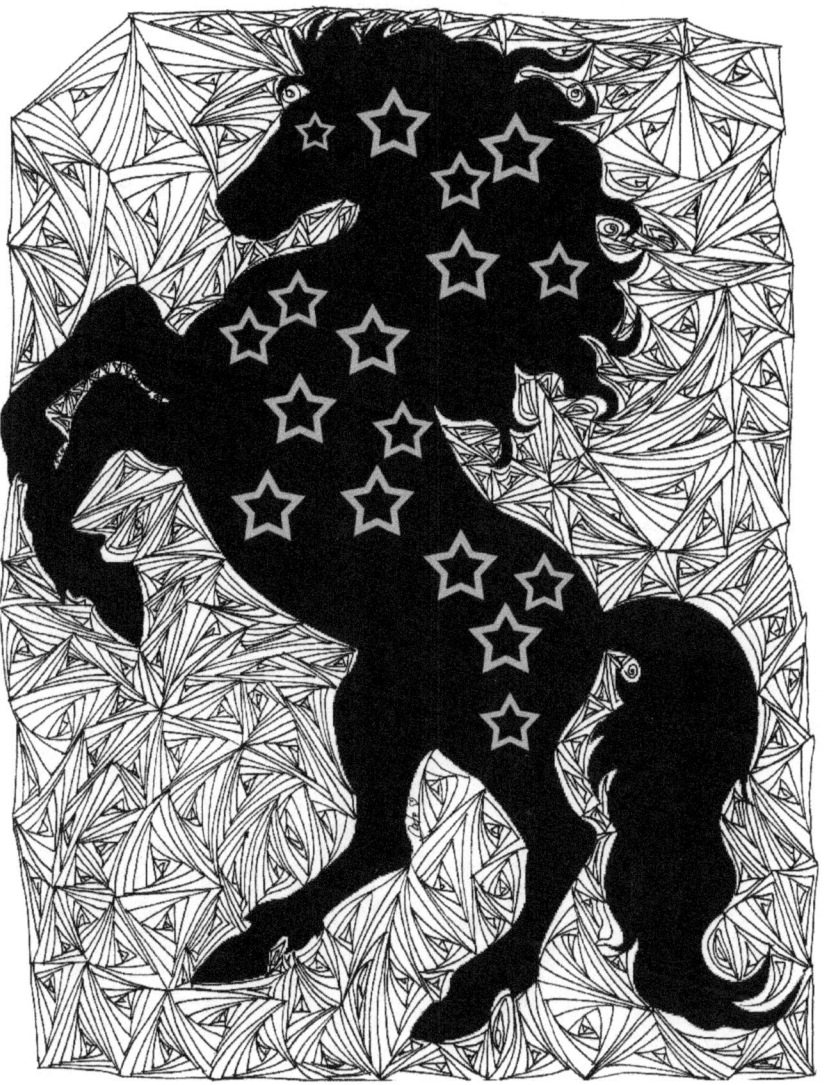

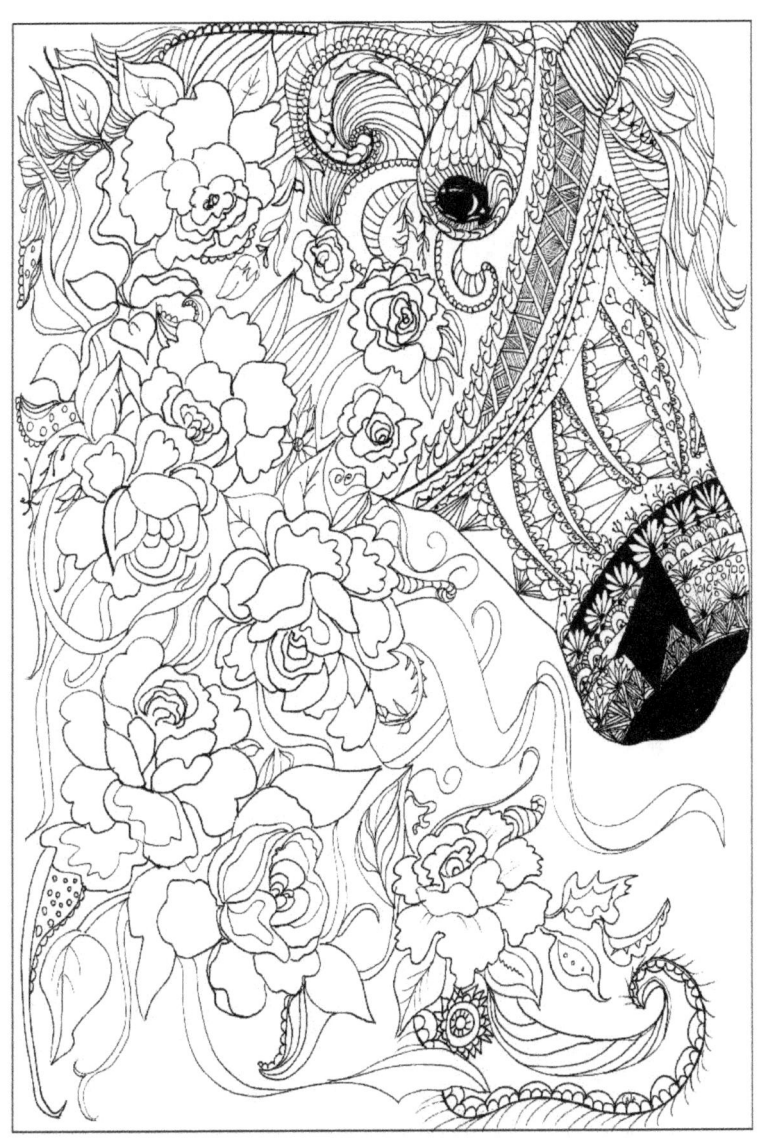

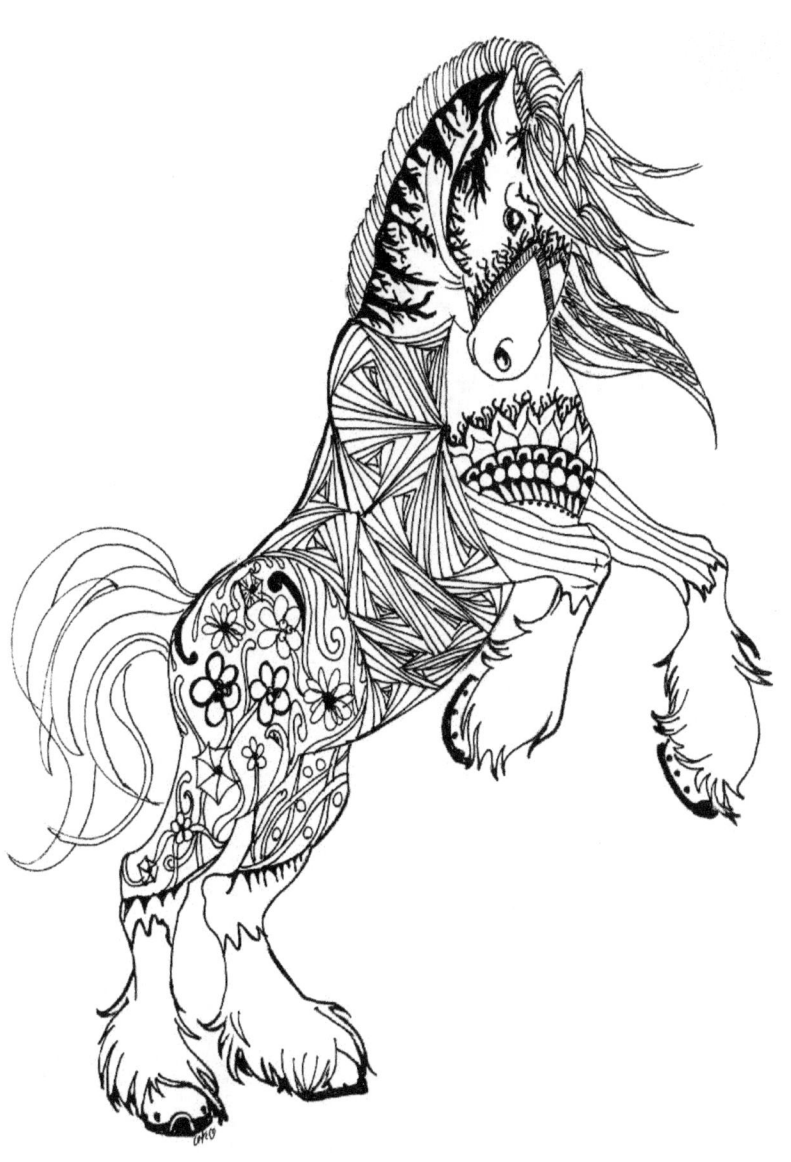

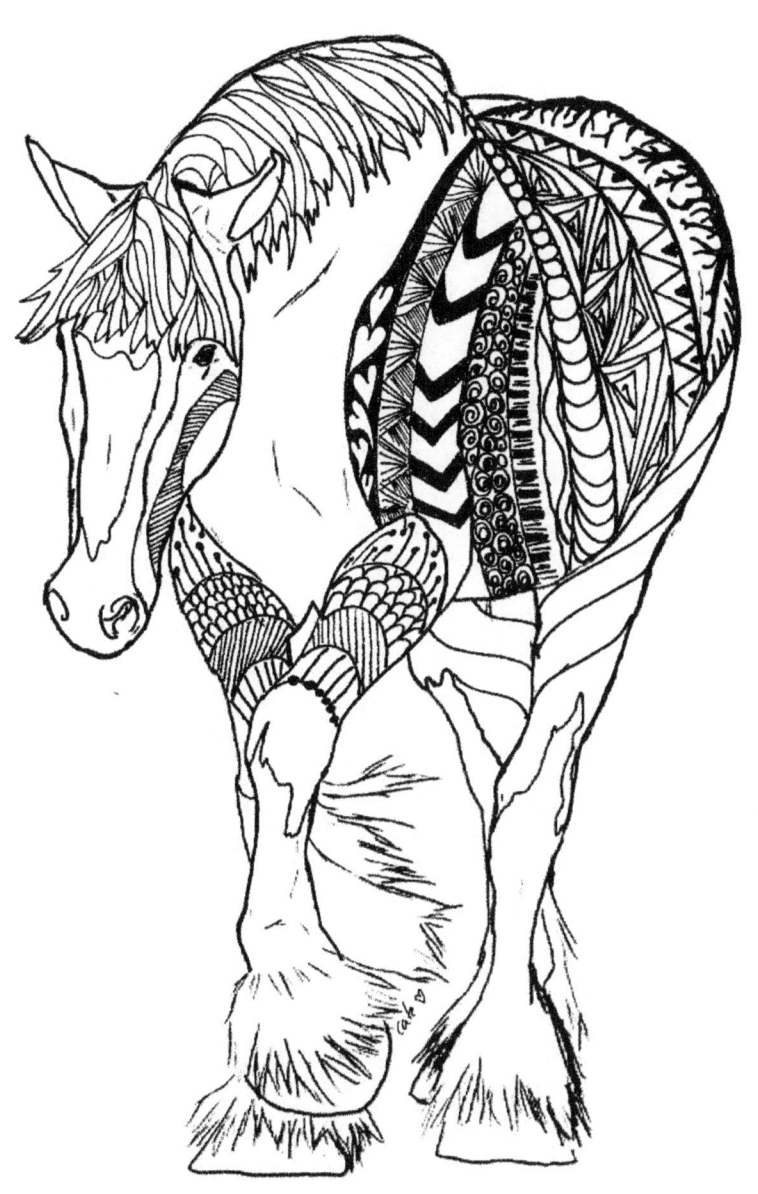

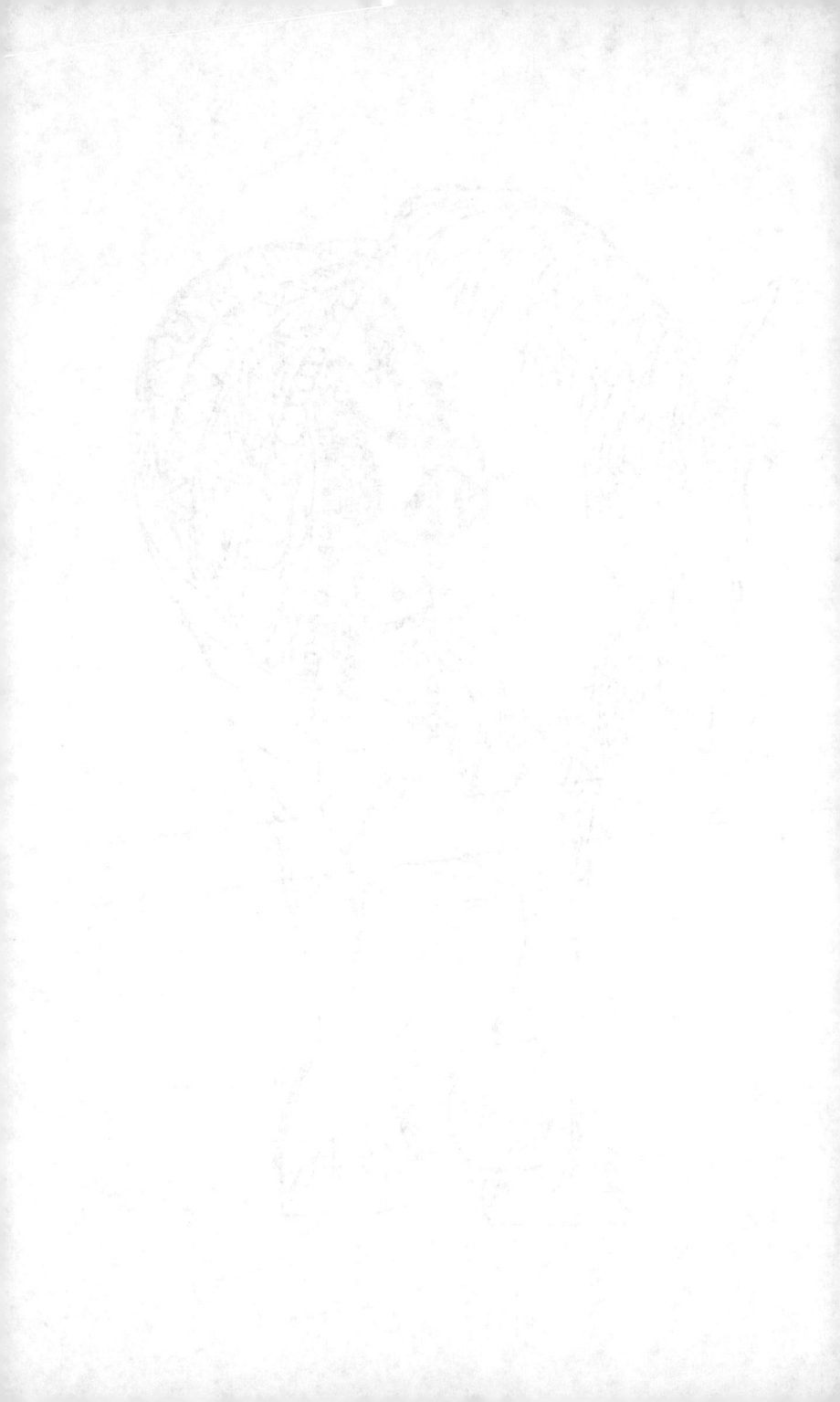

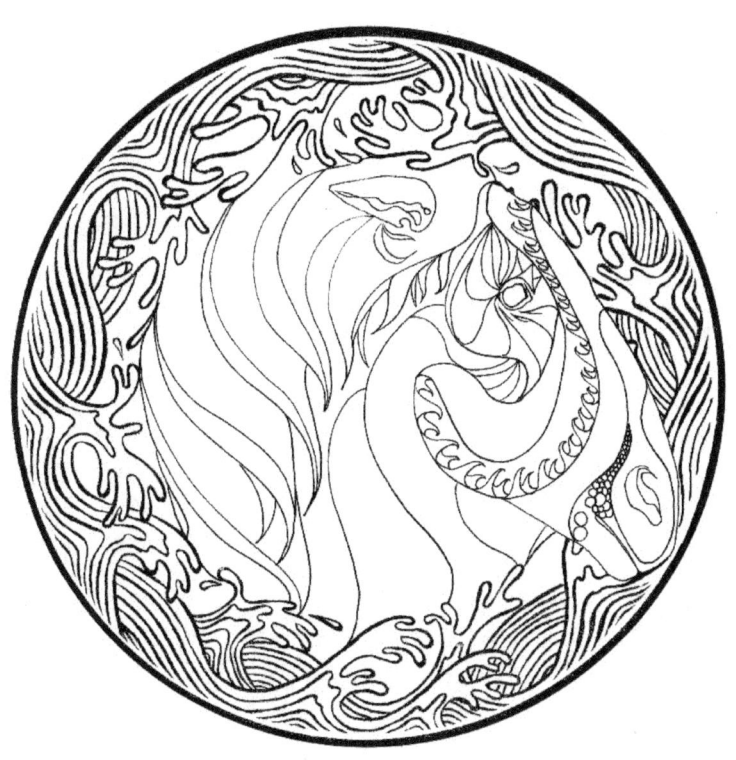

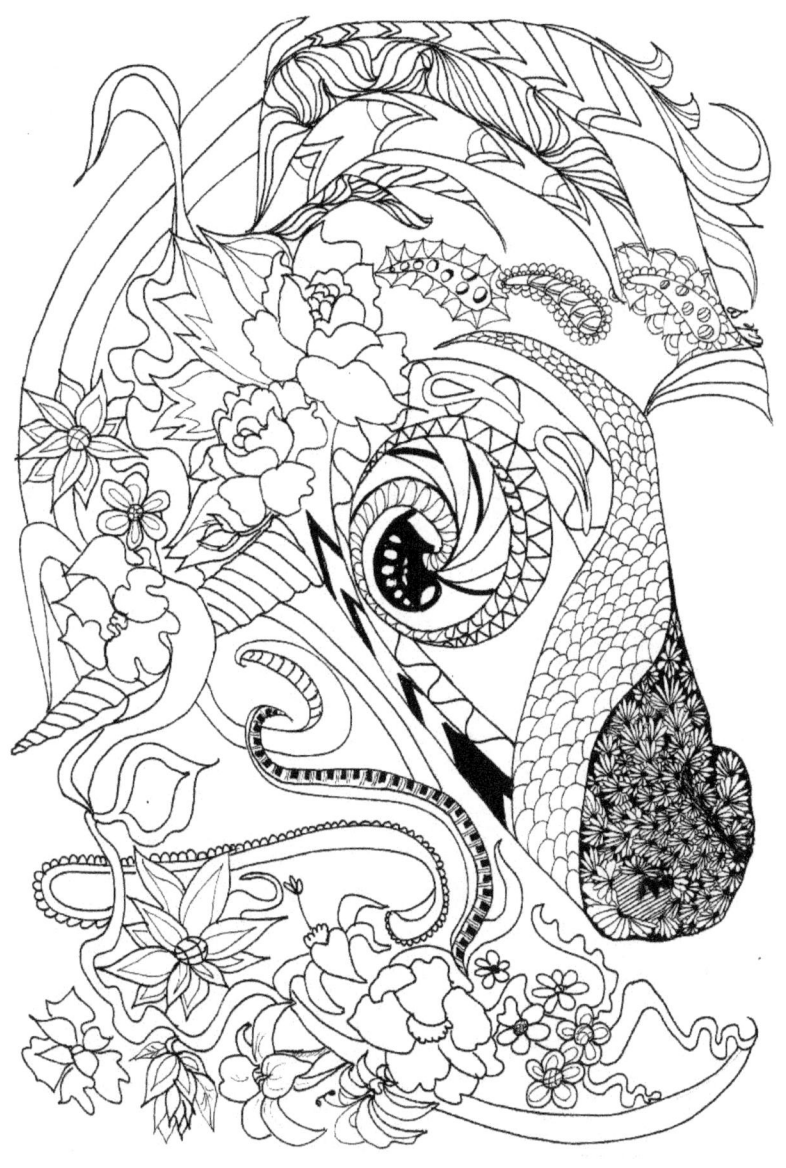

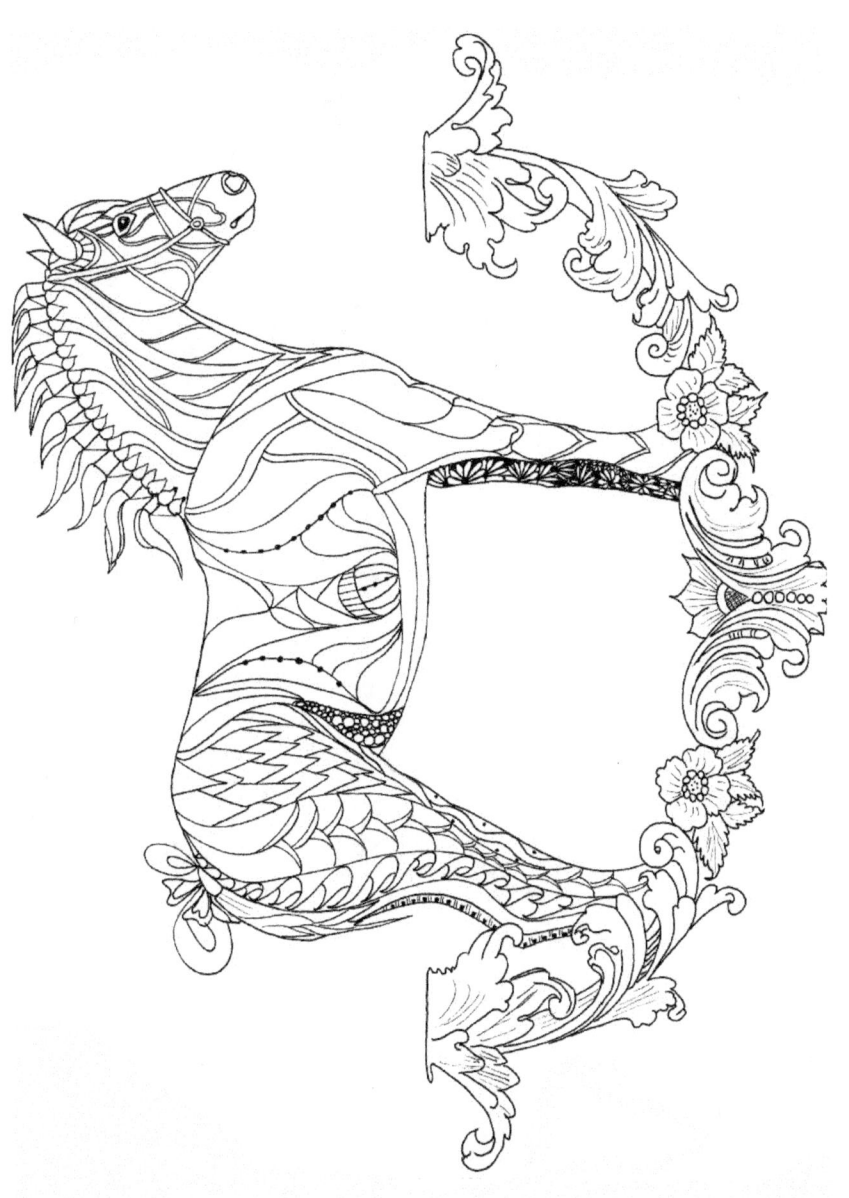

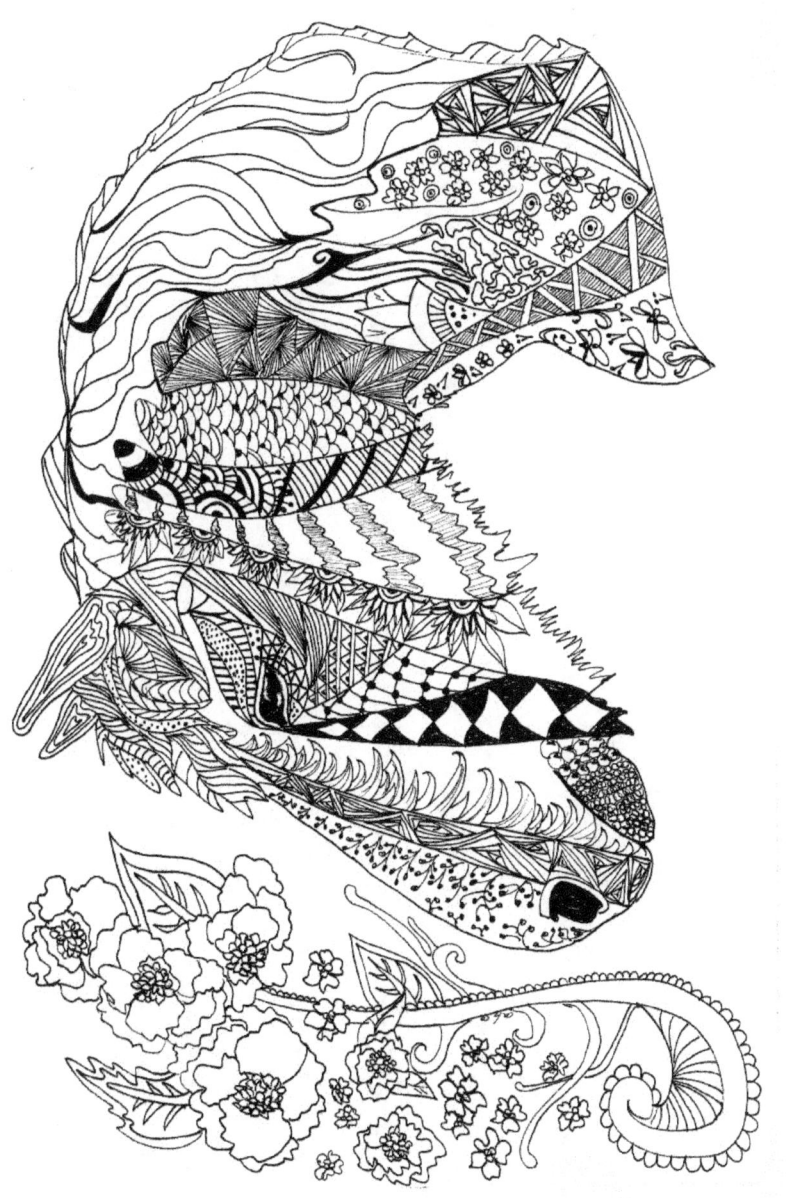

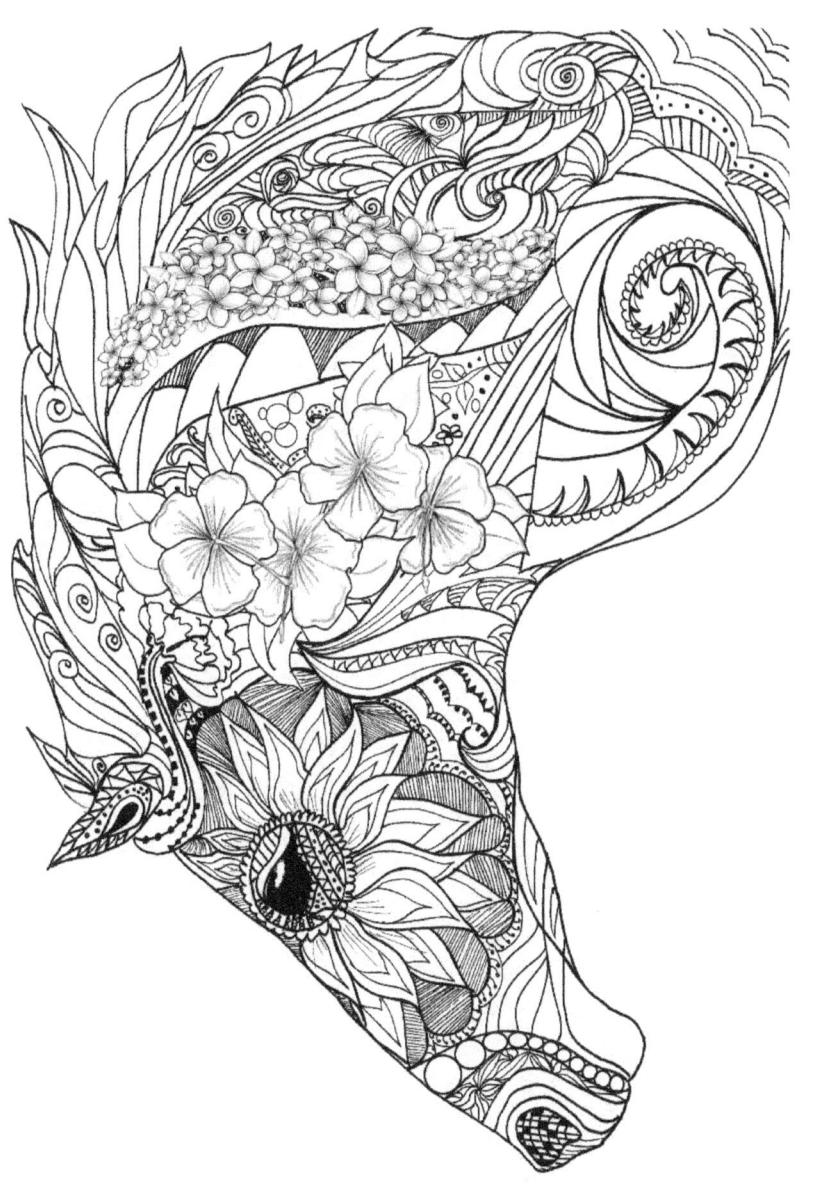

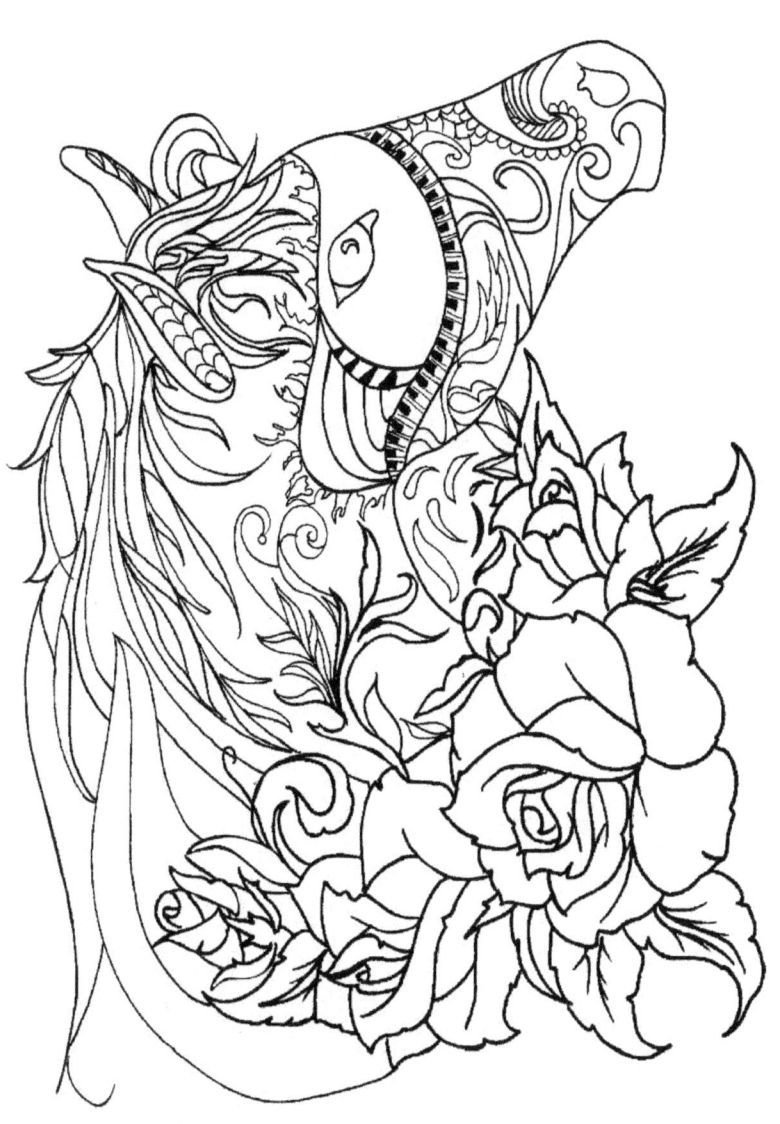

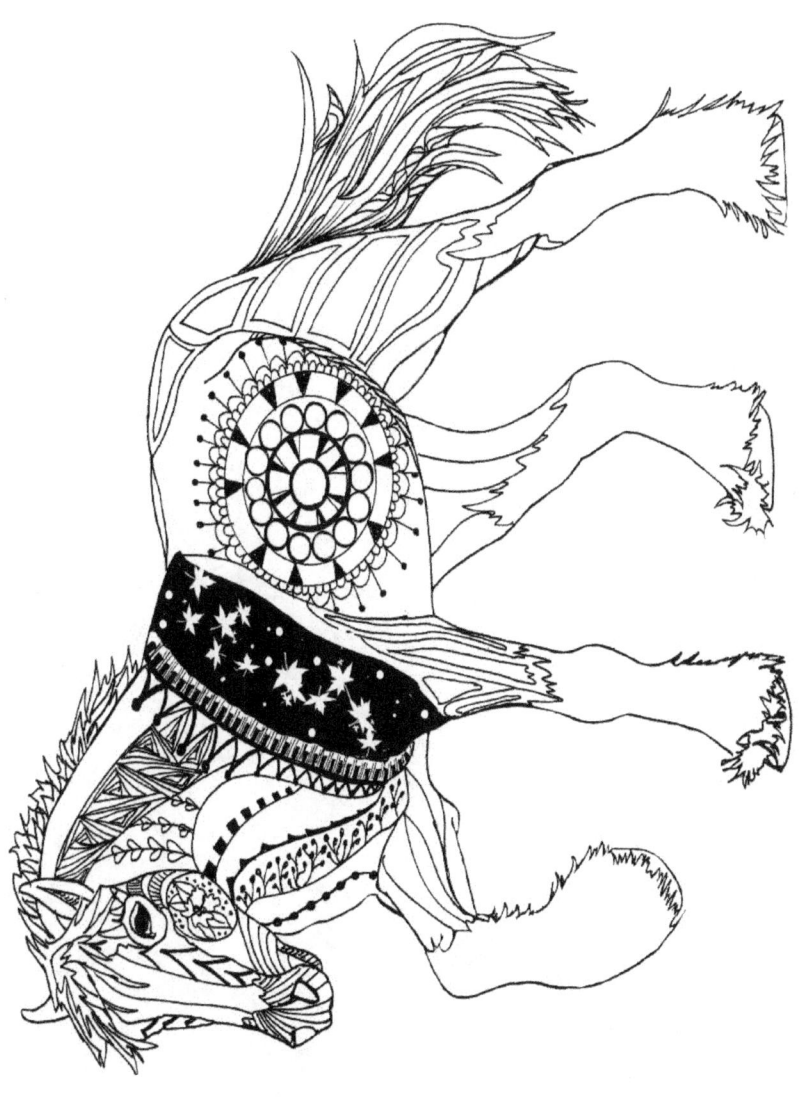

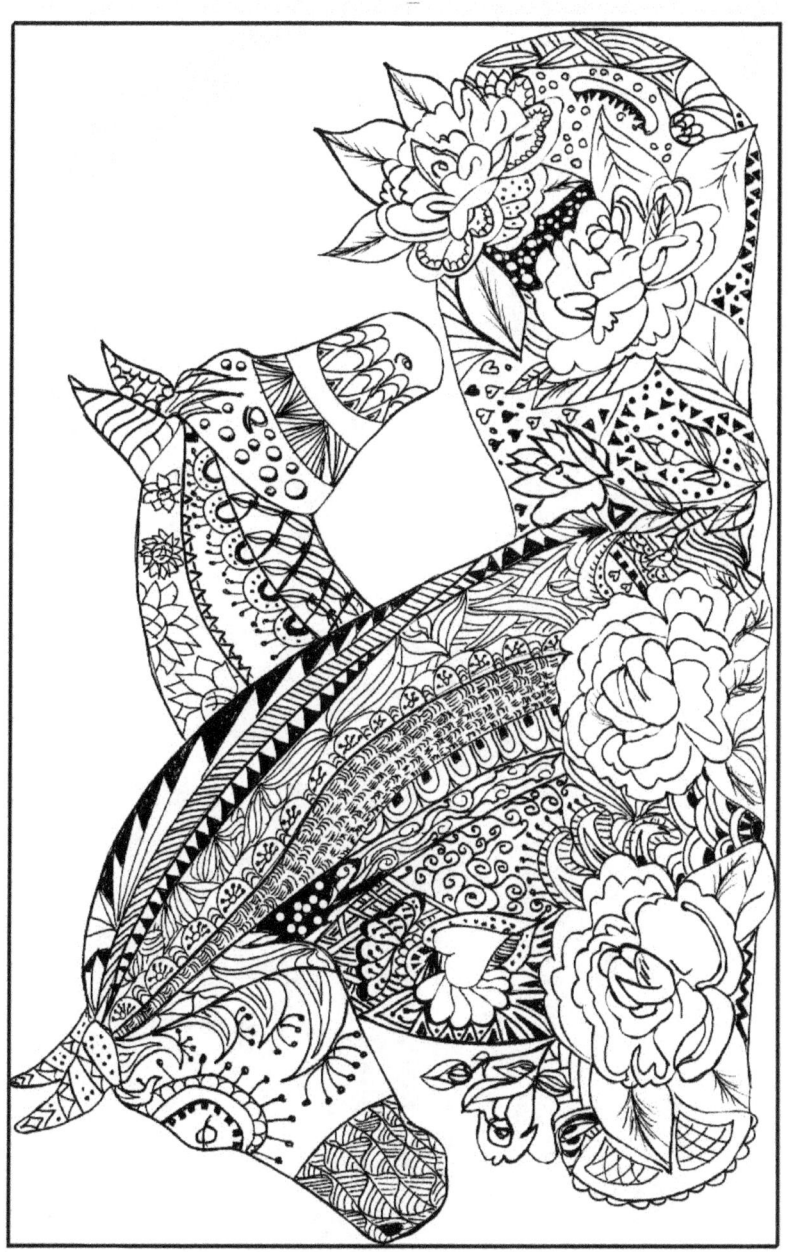

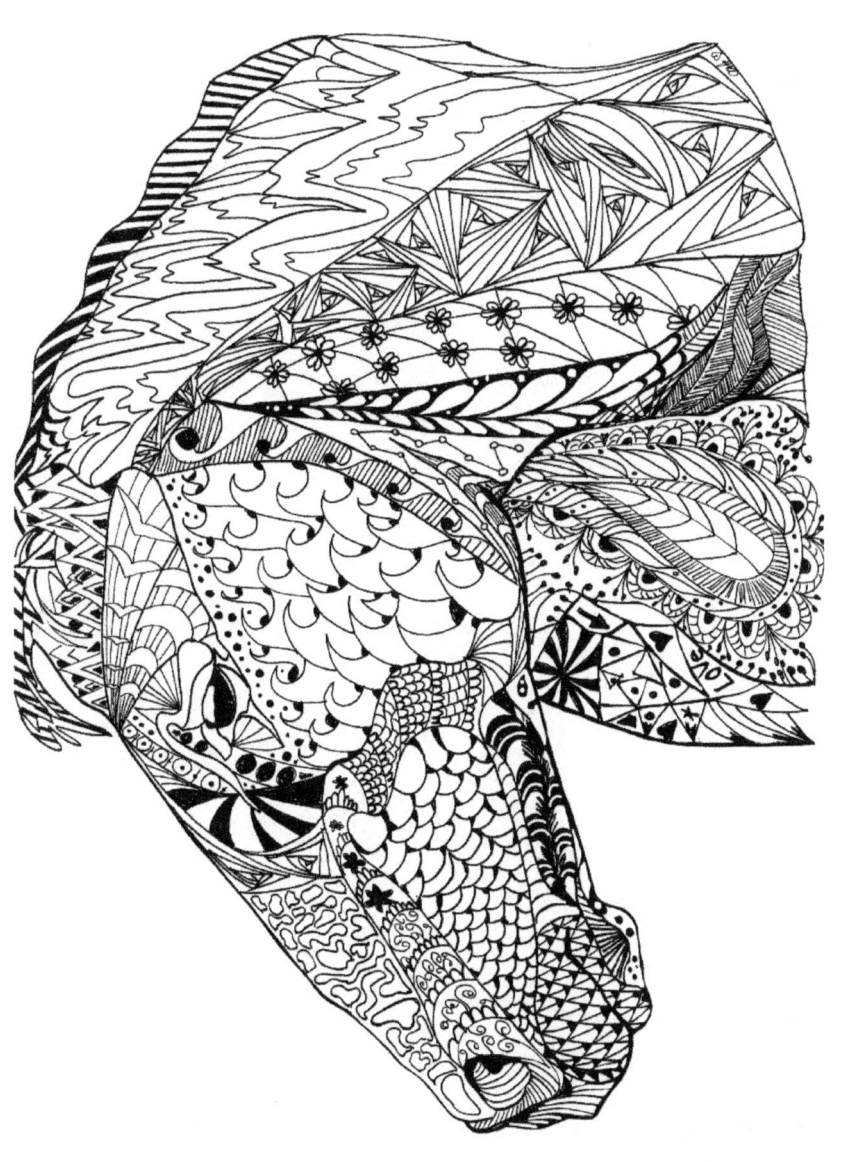

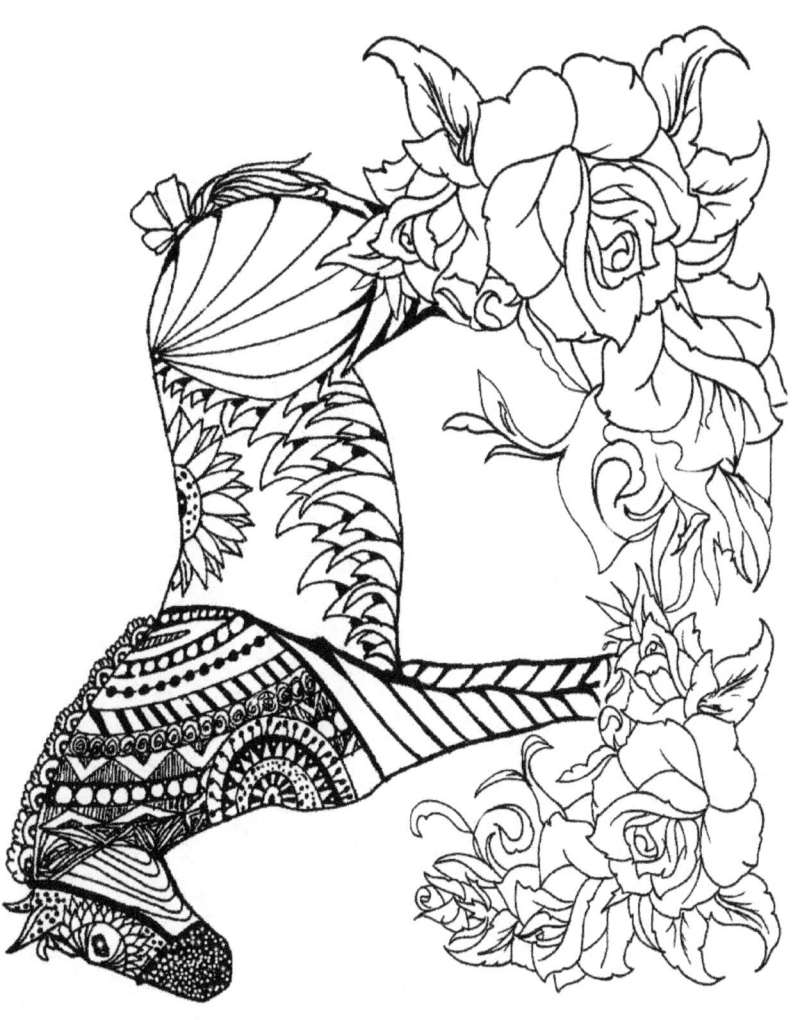

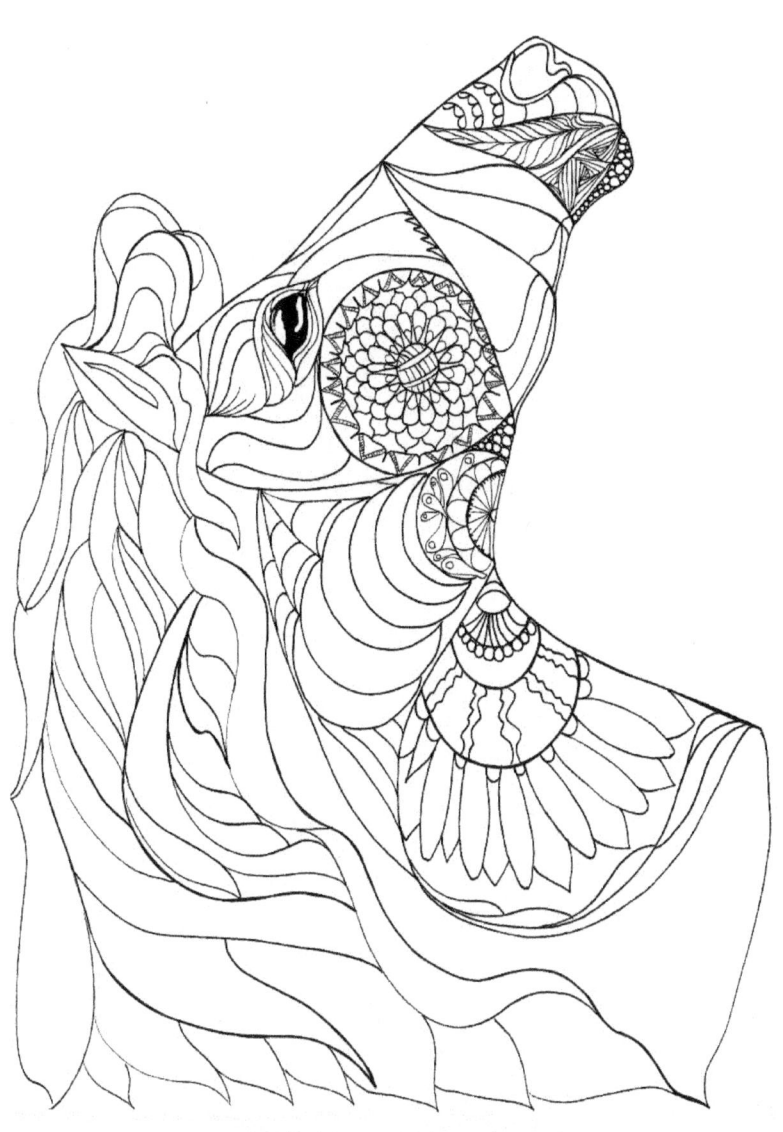

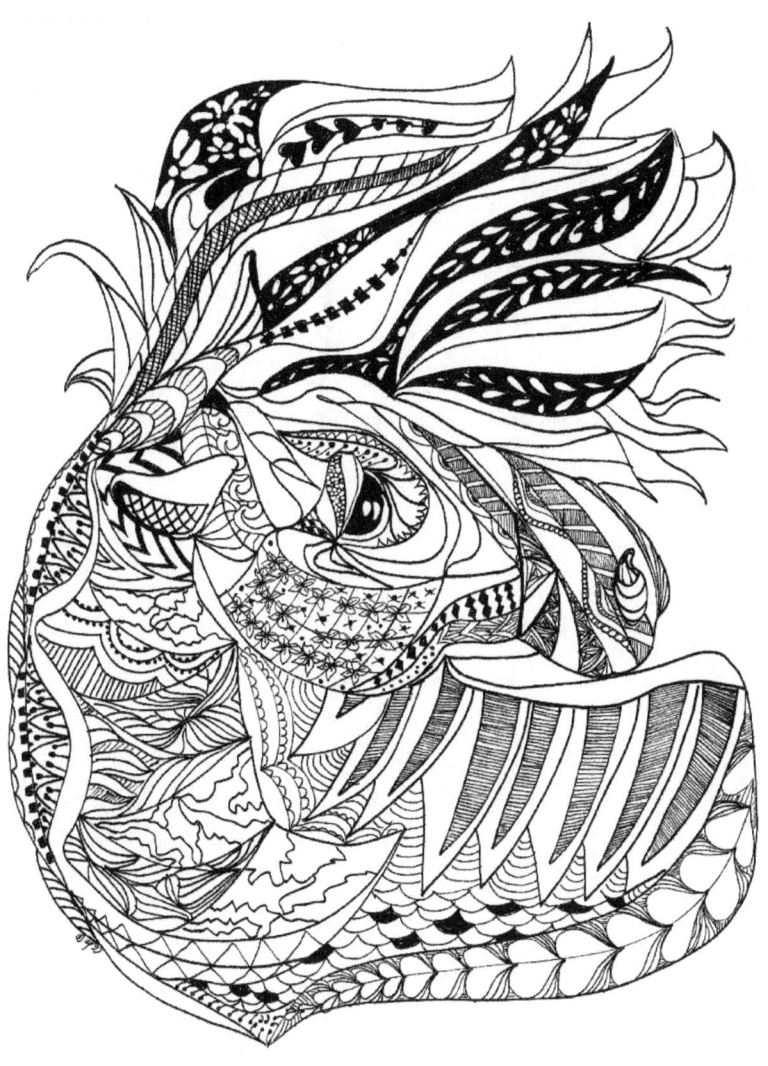

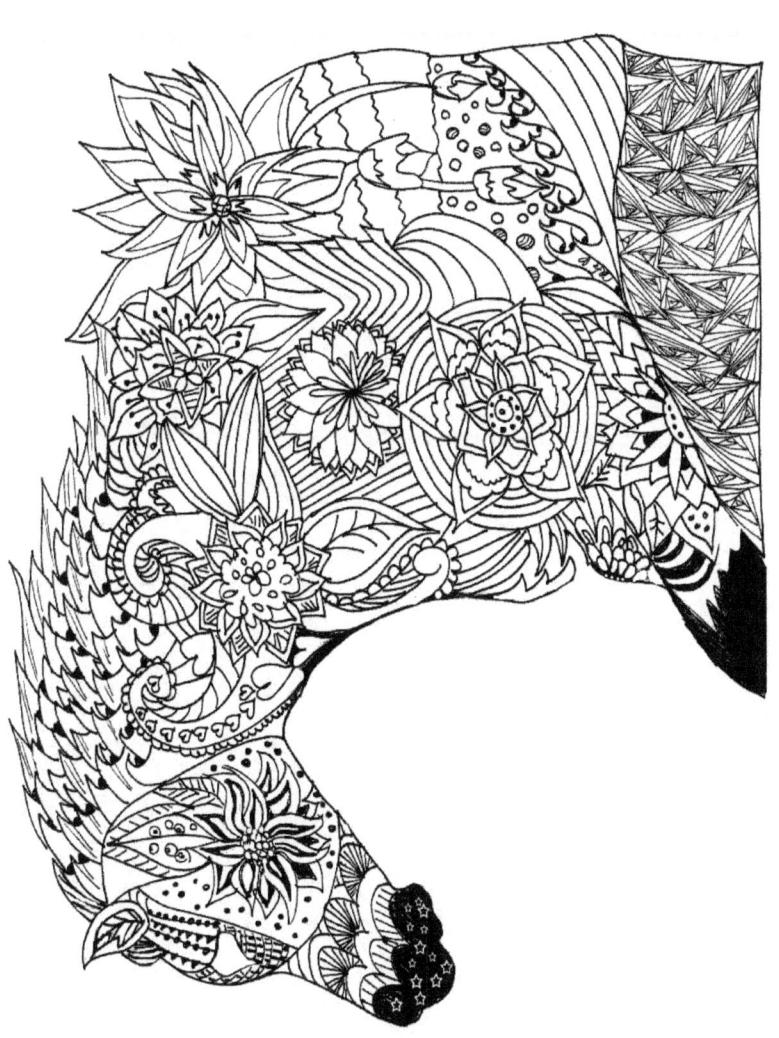

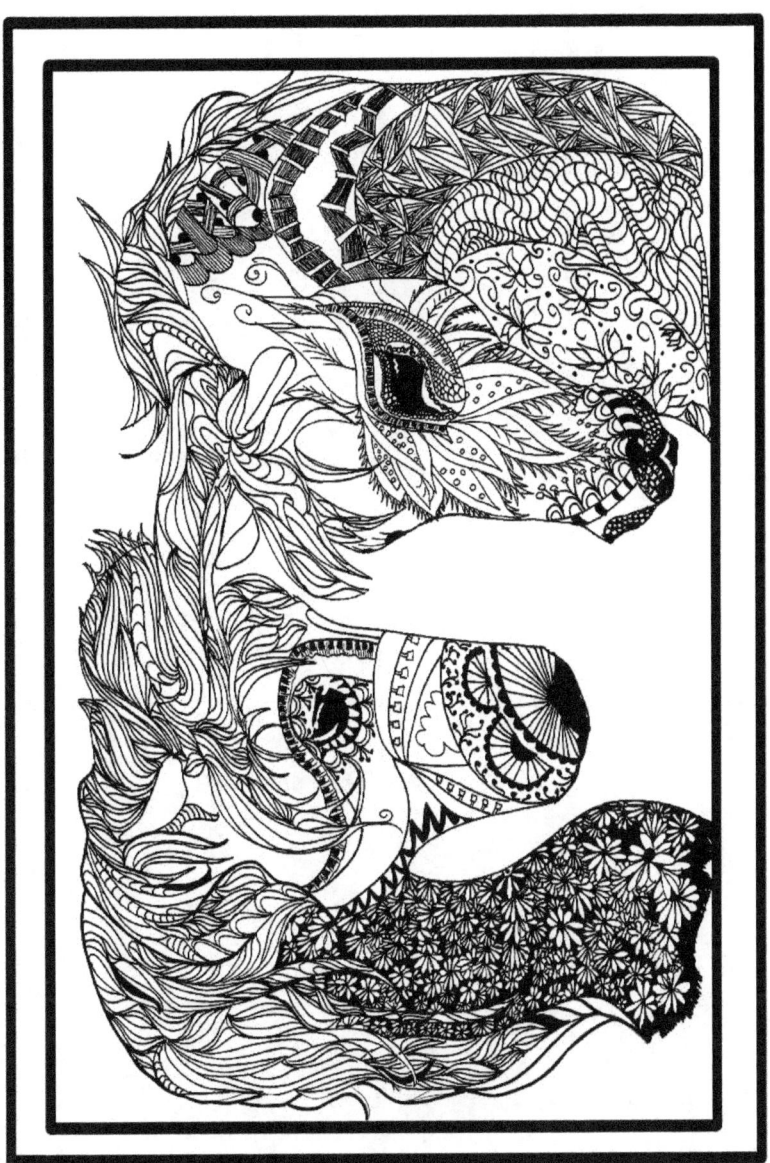

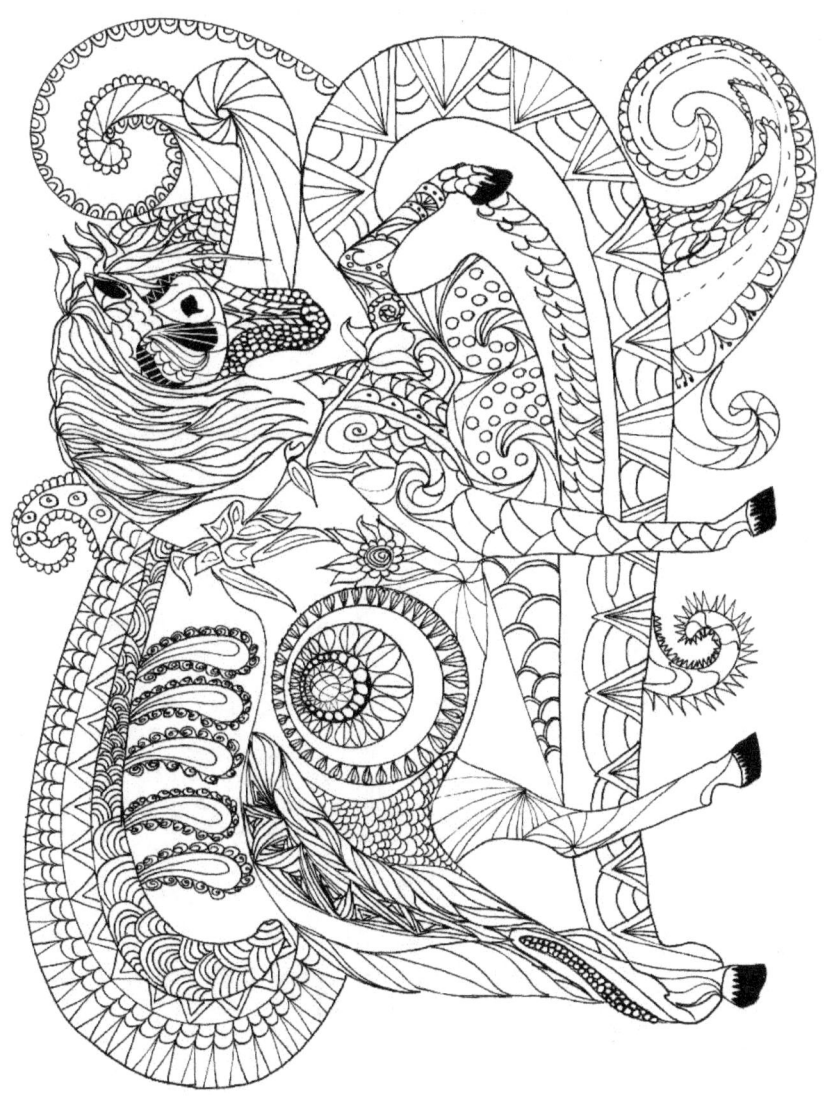

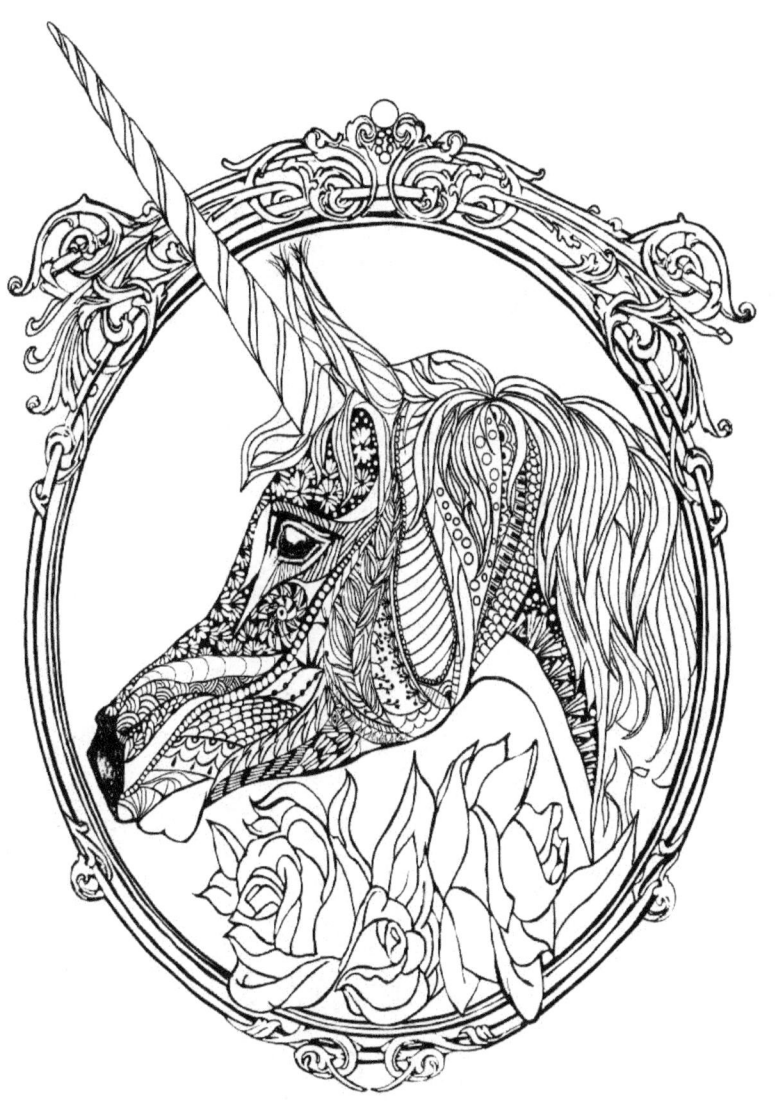

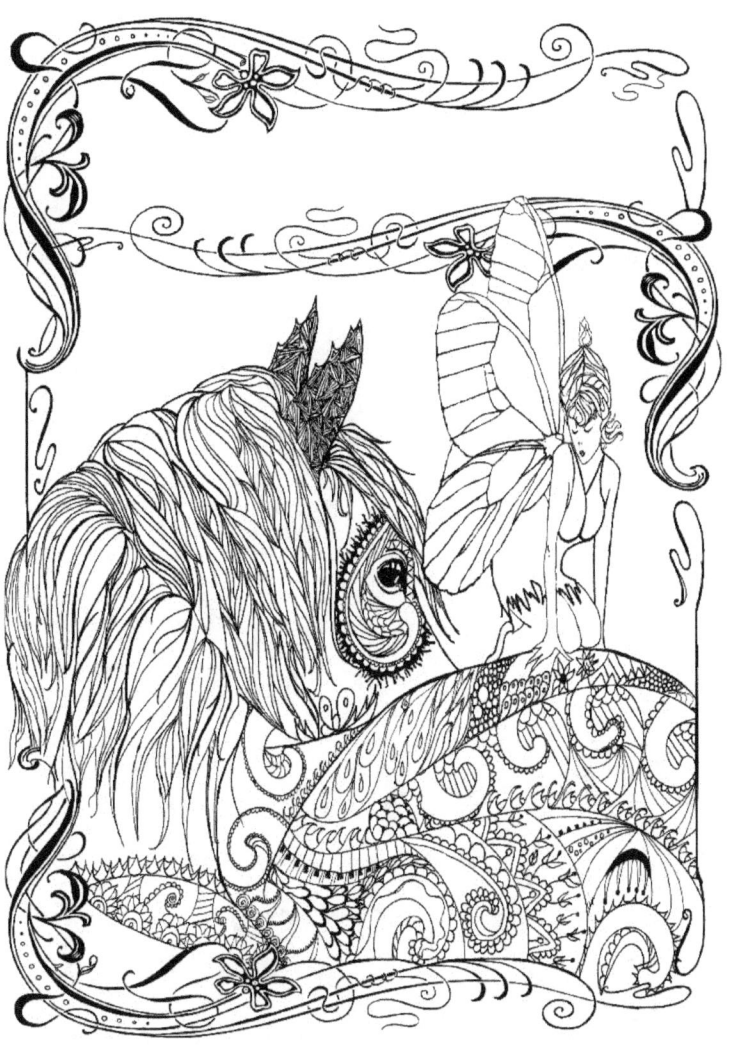

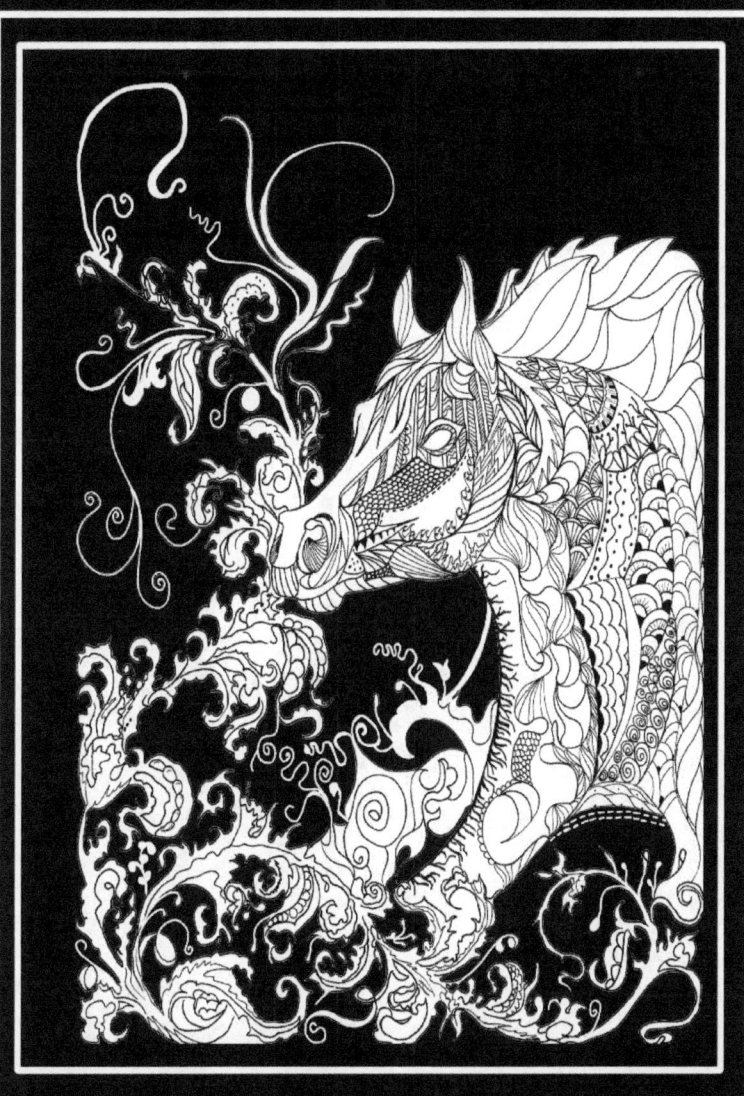

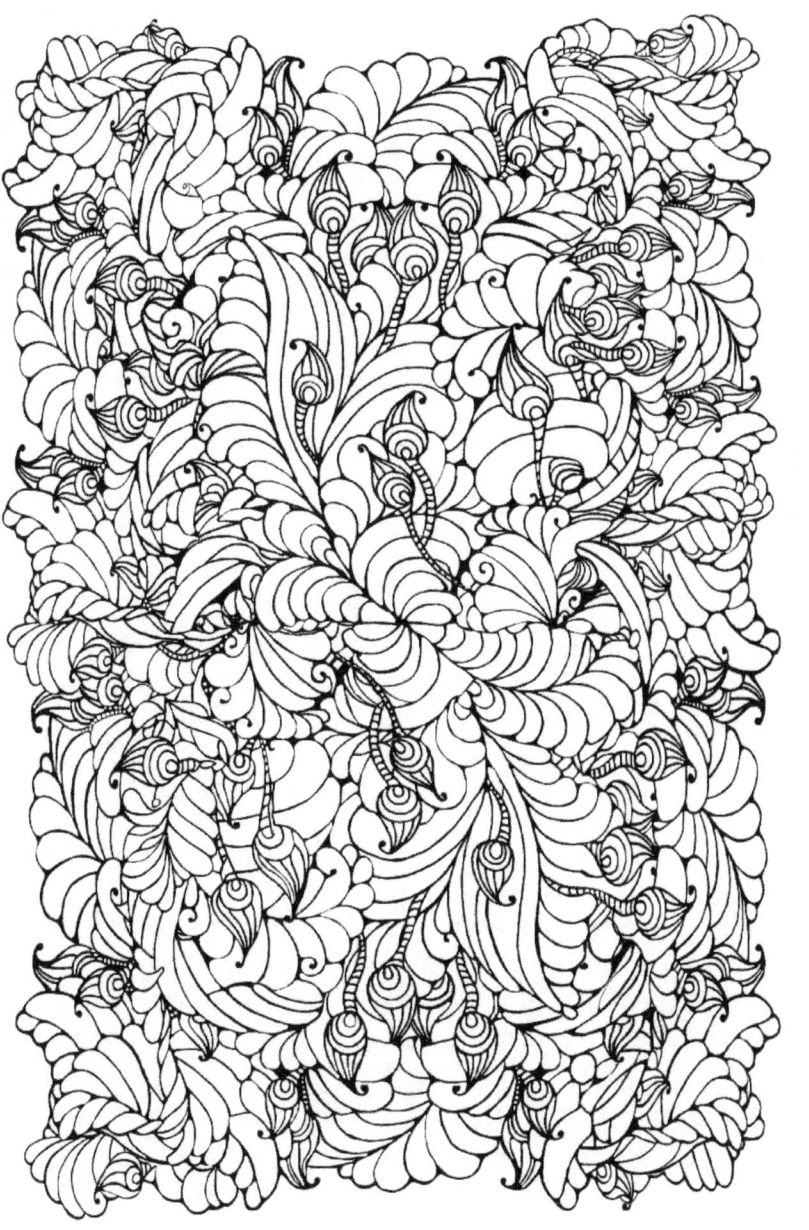

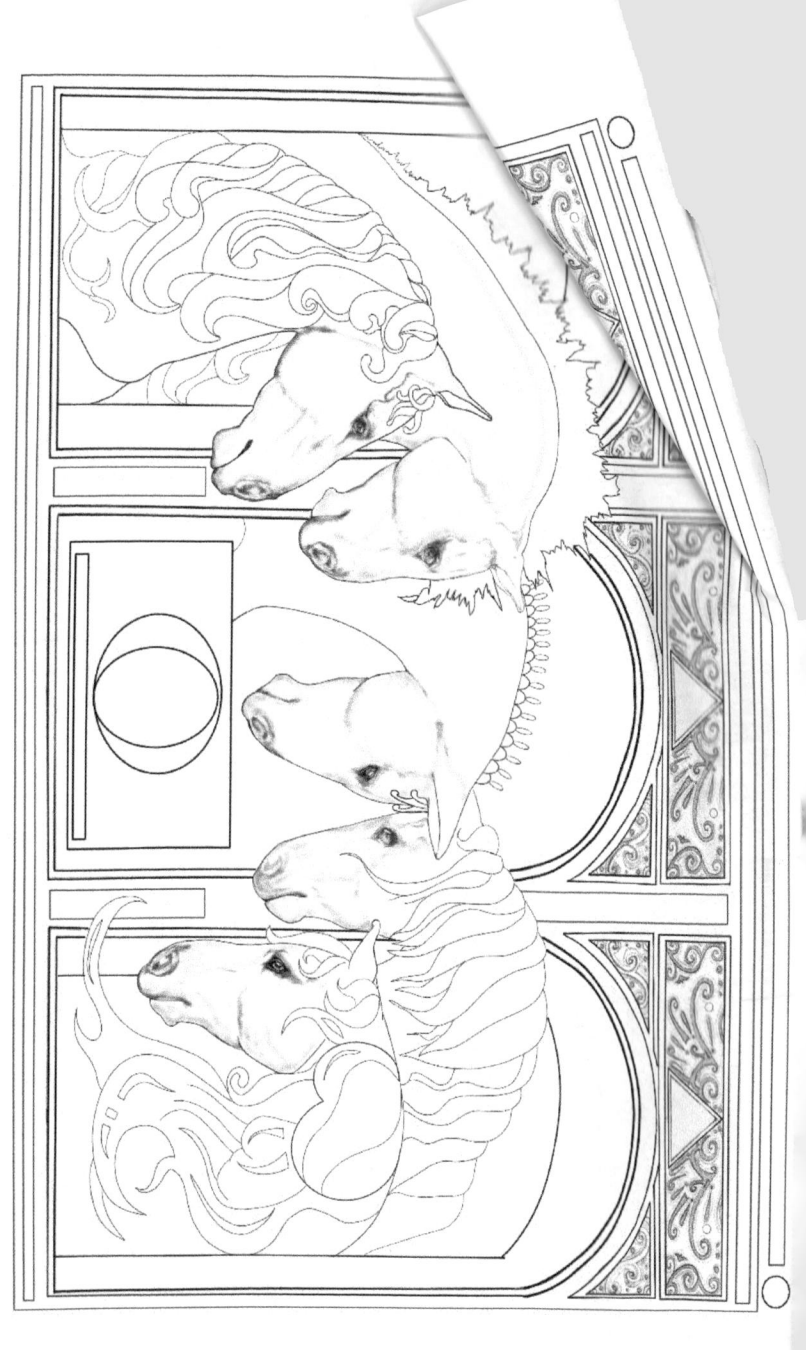

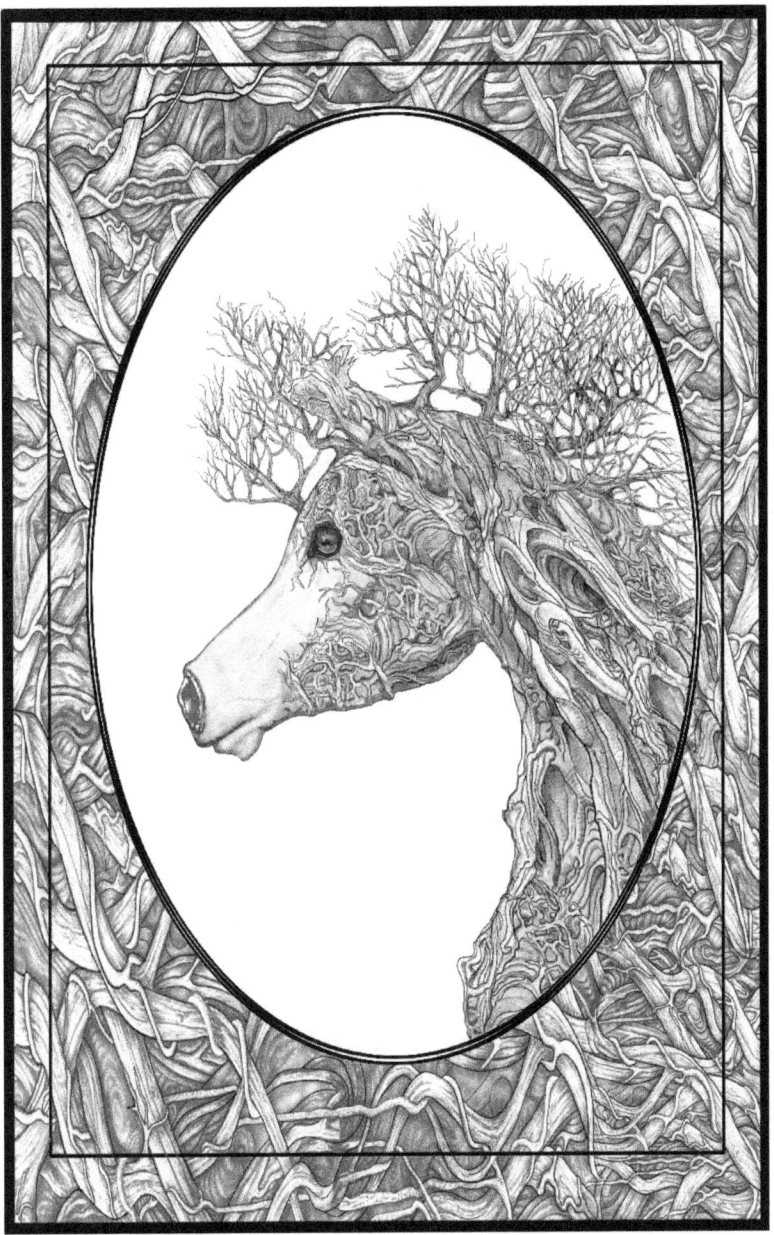

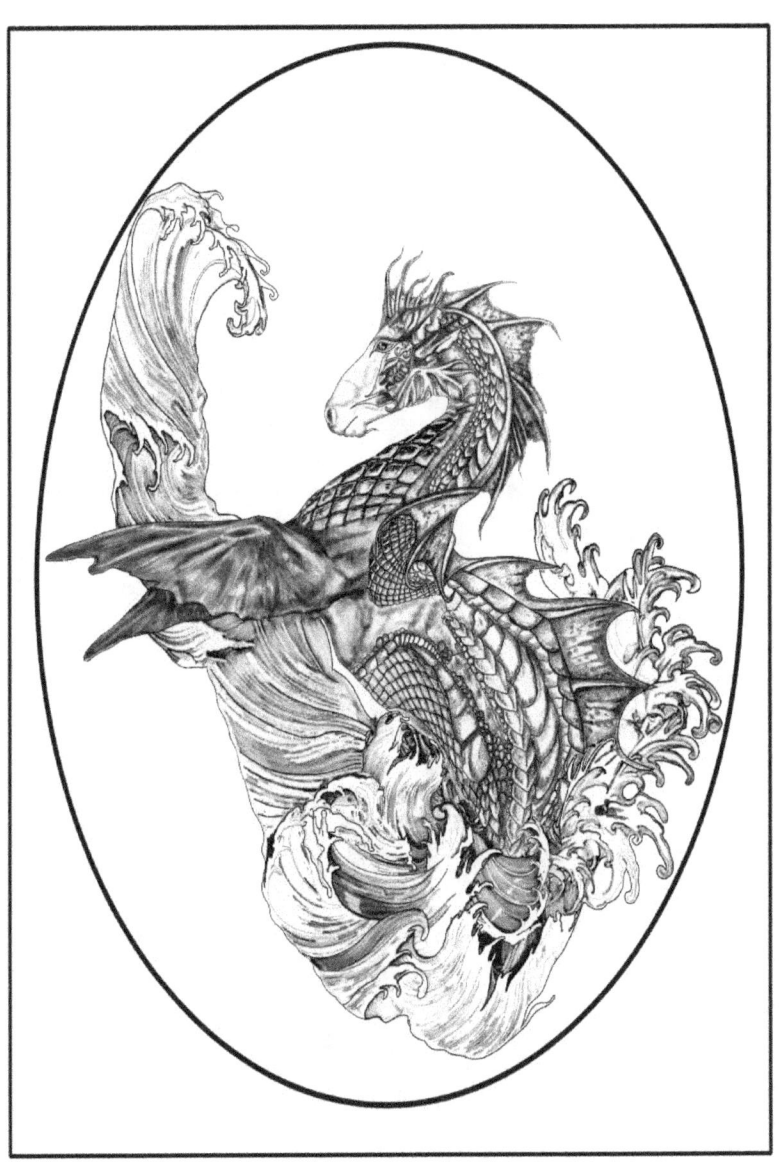

www.ingramcontent.com/pod-product-compliance
Lightning Source LLC
Chambersburg PA
CBHW061201180526
45170CB00002B/911